M000158317

THIS NOTEBOOK BELONGS TO ....................................................................................

CONTACT ............................................................................................................................

See our range of fine, illustrated books, ebooks, notebooks and art calendars:
**www.flametreepublishing.com**

This is a **FLAME TREE NOTEBOOK**
Published and © copyright 2021 Flame Tree Publishing Ltd

FTNBB16 • 978-1-78755-862-5

Cover image based on a detail from
*Portrait of Adele Bloch-Bauer I*, 1907
by Gustav Klimt (1862–1918)
© A. Burkatovski/Fine Art Images/SuperStock

Gustav Klimt is one of the best known artists of the Viennese Secession and the
Art Nouveau movement. *Portrait of Adele Bloch-Bauer I* is part of the artist's
groundbreaking Golden Phase. Inspired by Byzantine mosaics, the painting
is layered with gold and silver leaf, and embellished with a textured gesso
relief of elaborate geometric patterns.

FLAME TREE PUBLISHING | The Art of Fine Gifts
6 Melbray Mews, London SW6 3NS, United Kingdom